It's old with lots of new! It's big but friendly, too!

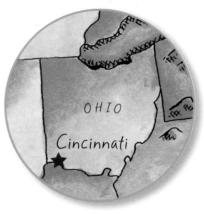

The places where you live and visit help shape who you become. So find out all you can about the special places around you!

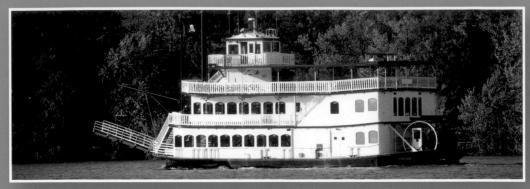

A paddleboat churns its way up the Ohio River.

CREDITS

Series Concept and Development

Kate Boehm Jerome

Design

Steve Curtis Design, Inc. (www.SCDchicago.com); Roger Radke, Todd Nossek

Reviewers and Contributors

Public Library of Cincinnati and Hamilton County Terry B. Flohr, writer and editor; Mary L. Heaton, copy editor; Eric Nyquist, researcher

Photography

Cover(a), Back Cover(a), i(a), vi(a) © Amy Nichole Harris/Shutterstock; Cover(b), Back Cover(b), i(b), iv, viii(c) © Doug Lemke/Shutterstock; Cover(c) © Svetlana Larina/Shutterstock; Cover(d), ii(a), xii(a), xii(a), xii(a), xvi(c), xvi(b) © Anne Kitzman/Shutterstock; Cover(e), x(a) © Tom Taintor; iii(a), vii(a) Courtesy Cincinnati Arts Association; v(a) by Mark Bowen/Flying Pig Marathon; vi(b) © from the A.G. Spalding Baseball Collection; vii(b) Lanskeith17/Wikimedia; viii(a) © John Keith/Shutterstock; vii(b) TheDapperDan/Wikimedia; ix(a), xvi(e) © Wally Gobetz, ix(b), ix(d), xiii(b), xvi(d) © Jayson C. Gomes, cincyimages.com; ix(c) © Richard Burn/Shutterstock; xi(b) © Kzenor/Shutterstock; xii(b) © Courtesy Glier's Goetta Company; xiv(a) Courtesy Library of Congress; xv(a) © Morgan Rauscher/Shutterstock; xv(b) © ShelbyBell/Wikimedia; xvi(b), xvi(g) © Bryan Busovicki/Shutterstock; xvi(f) © Robert J. Rockefeller/Shutterstock

Illustration

i © Jennifer Thermes/Photodisc/Getty Images

Copyright © 2010 Kate Boehm Jerome. All rights reserved. No part of this book may be used or reproduced in any manner without written permission except in the case of brief quotations embodied in critical articles and reviews.

ISBN 978-1-4396-0068-9 Library of Congress Catalog Card Number: 2009943364

Published by Arcadia Publishing Charleston SC, Chicago IL, Portsmouth NH, San Francisco CA

 For all general information contact Arcadia Publishing at:

 Telephone
 843-853-2070

 Fax
 843-853-0044

 Email
 sales@arcadiapublishing.com

 For Customer Service and Orders:
 Toil-Free

 Toil-Free
 1-888-313-2665

Visit us on the Internet at www.arcadiapublishing.com

Contents

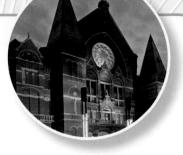

Cincinnati

Spotlight on Cincinnati	iv
By the Numbers	vi
Sights and Sounds	viii
Strange But True	Х
Marvelous Monikers	xii
Dramatic Days	xiv

Ohío

What's So Great About This State 1		
The Land 2		
Plains 4		
Appalachian Plateau6		
Lakes and Rivers		
The History 10		
Monuments 12		
Museums		
Canals		
The People		
Protecting		
Creating Jobs		
Celebrating24		
Birds and Words		
More Fun Facts		
Find Out More		
Ohio: At a Glance		

Spotlight Cincinatil

C incinnati stands on the northern bank of the Ohio River—nestled among the hills of the Ohio Valley and within easy sight of its Kentucky neighbors across the river. How many people call Cincinnati home?

The population within city limits is over 300,000. But the Cincinnati metropolitan area (the city and surrounding area) is home to more than 2 million people.

Are there professional sports teams in Cincinnati?

Absolutely! Cincinnati has three of them. The Reds (baseball), the Bengals (football), and the Cyclones (hockey).

What's one thing every kid should know about Cincinnati?

Although it started as a trading post, by the early nineteenth century Cincinnati became a boomtown and was the first major inland city of the country.

• n the first Sunday of May each year, Cincinnati has a big event with an unusual name. It's the Flying Pig Marathon!

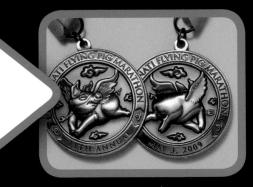

By The Numbers

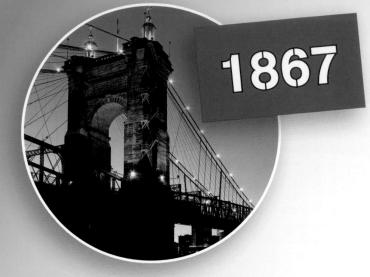

In that year, the John A. Roebling Suspension Bridge between Cincinnati and Covington, Kentucky, was opened. The Suspension Bridge is now a U.S. National Historic Landmark.

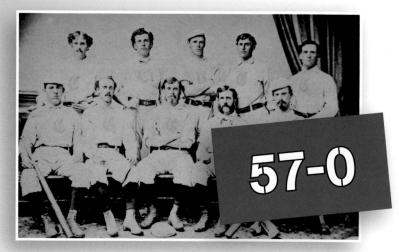

That's the win-loss record of the country's first professional baseball team organized in Cincinnati in 1869. It was a good start, but the Red Stockings folded after the 1870 season. Happily, the club reorganized and the Cincinnati Reds came to bat in the National League lineup in 1876.

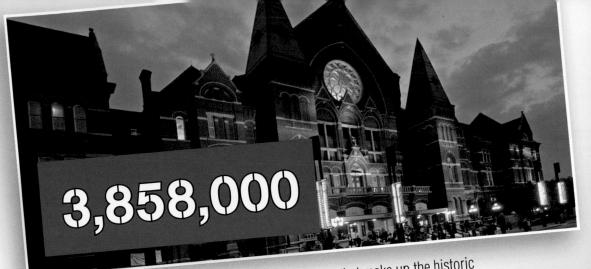

That's the approximate number of red-pressed bricks that make up the historic Cincinnati Music Hall.

The Findlay Market is the only city market house to survive from all the public markets that existed in the city in the nineteenth and early twentieth centuries.

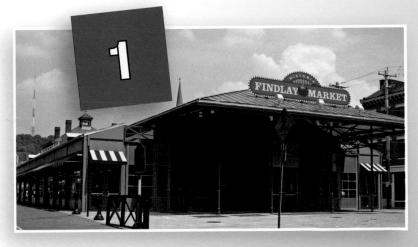

More Numbers!

[1819	The year Cincinnati was chartered as a city.	-
F	52	The number of neighborhoods that make up Cincinnati.	
	180	The span (in feet) of the Rotunda interior dome inside Union Terminal.	v

Cincinnati: Sights Sounds

Hear

...the sounds of jazz each summer at the Cincinnati Jazz Festival.

Sme]]

...the aroma of chili! Cincinnati's special recipe is chili served over spaghetti with shredded cheddar cheese on top. The oyster crackers are up to you!

...the fresh air, trees, and flowers in the more than 5,000 acres of parks and green areas throughout the city.

See

...an original floating theater! The showboat *Majestic* was first launched in 1923. It traveled to ports along the Ohio River for many years but is now permanently docked at Cincinnati's Riverfront.

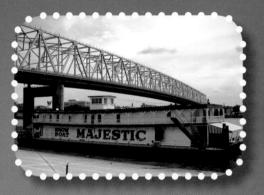

...rare animals at the Cincinnati Zoo and Botanical Garden, which is the second oldest zoo in the United States (More endangered cheetahs have been born in the Cincy zoo than in any other zoo in the world!)

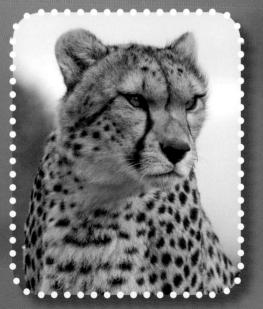

Explore

...the amazing Cincinnati Museum Center at Union Terminal. It contains the Cincinnati History Museum, the Duke Energy Children's Museum, and the Museum of Natural History and Science. It also has an Omnimax theater—and believe it or not— Amtrak trains stop here, too!

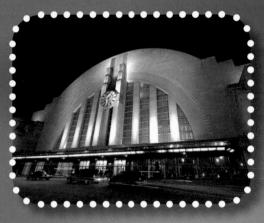

...one of the most walkable cities in the country. Most neighborhoods are pedestrian-friendly!

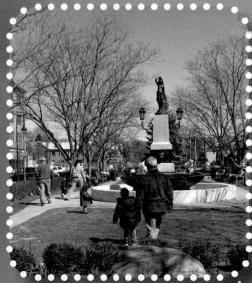

THE BIG PIG GIG

In the summer of 2000, more than 400 decorated life-size pig statues (some even flying) were placed all around Cincinnati. This public art display honored the city's pork heritage from its nineteenth century meat-packing days. (Cincy was once nicknamed "Porkopolis!") Today, many of the pig statues still stand in downtown offices, parks, and even the airport.

Gasha

AN ABSENT AIRPORT

The Cincinnati airport is not in Cincinnati. It's not even in Ohio. Cincinnati's airport is really in Kentucky and is called the Cincinnati/Northern Kentucky International Airport.

WORLD'S LARGEST CHICKEN DANCE

It happens every September at the Oktoberfest (called Oktoberfest Zinzinnati). In 1994—the record-setting year—48,000 people participated in the dance. The dance is just a part of the Oktoberfest, which celebrates Cincinnati's rich German heritage.

incinnati:

What's a moniker? It's another word for a name...and Cincinnati has plenty of interesting monikers around town!

historic neighborhood of **Mount Adams**. It was named after President John Quincy Adams.

Mount Adams

Goetta

A Tasty Name

Goetta— a meat made mostly of ground meat, oats, and seasonings—is a favorite Cincinnati breakfast food.

Purple People Bridge

A Colorful Name

The Newport Southbank Bridge stretches over the Ohio River to connect Cincinnati with Newport, Kentucky. Known as the **Purple People Bridge**—it's the longest pedestrian bridge connecting two states in the whole country.

Fountain Square

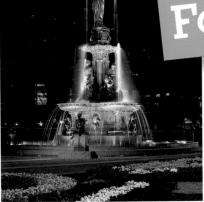

A Central Name

Fountain Square is in the middle of downtown Cincinnati. Its main attraction is the Tyler Davidson Fountain, which was dedicated to the people of Cincinnati in 1871.

The Queen City Changing Names

When it was first settled in 1788, Cincinnati was called Losantiville. It was renamed Cincinnati in 1790. In the 1800s, people began praising Cincinnati as the **Queen City**—a nickname that is still used today.

Floods can be a problem for a river town like Cincinnati. February 1883, January 1907, and January 1937 all brought catastrophic floods to the city as the Ohio River swelled over its banks. The 1937 flood was called the Great Flood. The Ohio River continued to rise for almost three weeks. Schools and businesses closed. Electricity had to be rationed. After that flood, protective walls were built to help hold future river risings in check.

Cincinnati was walloped by a huge storm in January 1978. Only about seven inches of snow fell but winds raged at 50 to 70 miles per hour. Huge drifts buried cars and brought down power lines. Wind chills of 67 below zero made it deadly to stay outside.

A BIG

A large explosion took place in Cincinnati on December 29, 2002. But don't worry—it was planned! Cinergy Field (formerly known as Riverfront Stadium) was demolished to make room for the Great American Ball Park, the new Cincinnati Reds baseball stadium. Fourteen hundred pounds of explosives crumpled the huge structure in just 37 seconds!

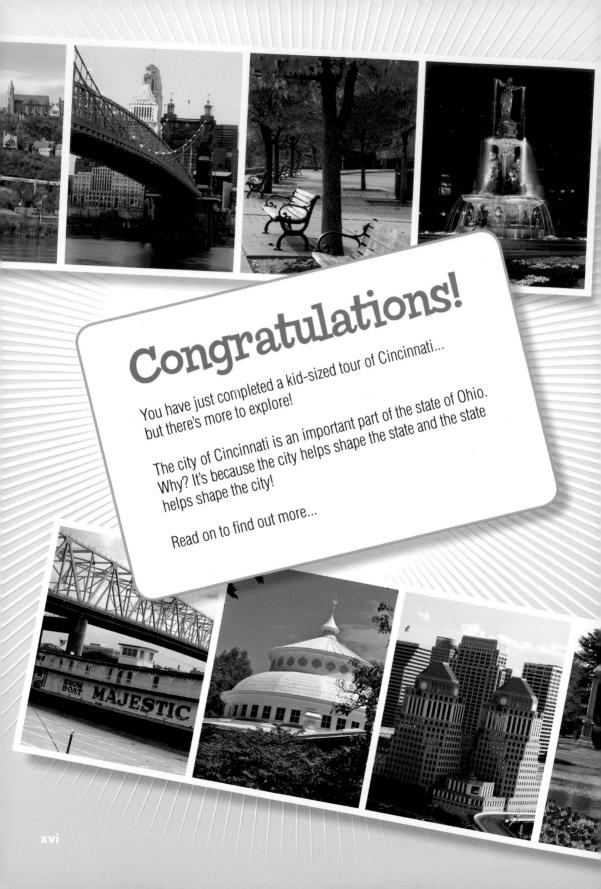

There is a lot to see and celebrate...just take a look!

Ohio

What's So

About This

CONTENTS

Land	pages 2-9
History	pages 10-17
People	
And a Lot More Stuff!	

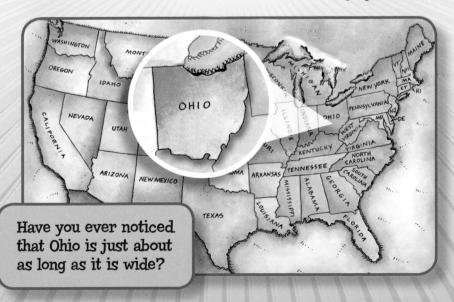

What's So Great About This State? Well, how about... + ho location of the state of

From Lake Erie...

Glaciers last disappeared from Ohio about 10,000 years ago. But these huge masses of ice certainly left their mark on the state!

Lake Erie—which forms most of the northern border of the state is a huge leftover "puddle" from the melting glaciers. But that's not all. Most of the land that the glaciers once covered is fairly flat (with just small rolling hills) due to the scraping action of the ice.

This Lake Erie lighthouse stands at the entrance to the Conneaut harbor. The city of Conneaut is in the most northeastern point of the Great Lakes Plains region.

"Knee-high by the Fourth of July!" This old Midwestern saying refers to the height of corn—which is a crop that grows well in the rich soil of the Plains region.

...to the Ohio River

Southeastern Ohio has quite a different landscape. Not all of this area was affected by glaciers, so it has high hills, steep cliffs, and deep valleys.

The state is named after the Ohio River, which forms the southern boundary of the state. The river received its English name from an Iroquois word meaning "great river."

It's quite an adventure to explore the land across Ohio. Turn the page to see just some of the interesting places you can visit!

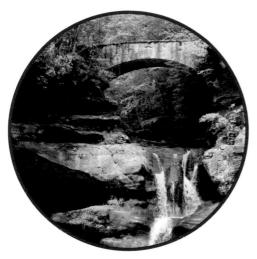

This waterfall is in Hocking Hills State Park in the Appalachian Plateau region of the state.

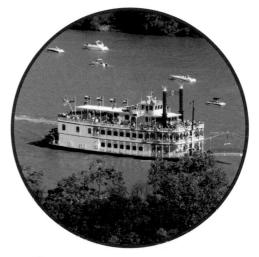

All sorts of boats—including a historic riverboat—travel the Ohio River.

Brandywine Creek runs through Cuyahoga National Park.

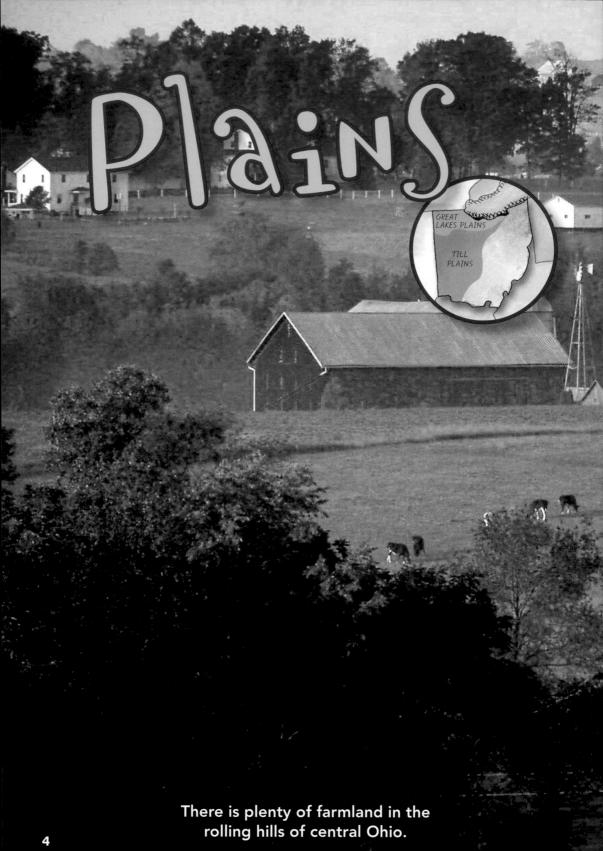

About two-thirds of the state is part of the Plains region. The Great Lakes Plains surround the shores of Lake Erie. The Till Plains named after the mixture of sand, gravel, rocks, and other "till" that the glaciers left behind—covers most of the western part of the state. The northern area is the flattest. The central and eastern parts of the Plains have more gently rolling hills.

What's so special about the Plains region?

Well, it's back to the glaciers again! Those huge masses of ice not only shaped the land, they also contributed to what's in it. Rich soil makes much of this region great for farming. In fact, Ohio is one of only four states in the country where over half of its land is suitable for growing crops. Corn and soybeans are two favorite crops.

The capital city of Columbus is in the Plains region.

What kind of things can I see in the Plains?

More than half of Ohio's state parks are in the Plains regions. That means lots of great picnic areas. There are also plenty of hiking and biking trails. Many different creatures live in this region including white-tail deer, raccoons, and red foxes, to name a few.

Don't forget the porcupines!

Yes, porcupines also live in the northern part of this area. However, you aren't too likely to run into these prickly creatures because they mostly come out at night.

By the way, porcupines can't really shoot their quills through the air. But if another animal comes in contact with them, the quills can detach with a painful stick.

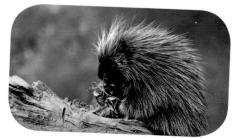

The porcupine has thousands of sharptipped quills that can make quite a point!

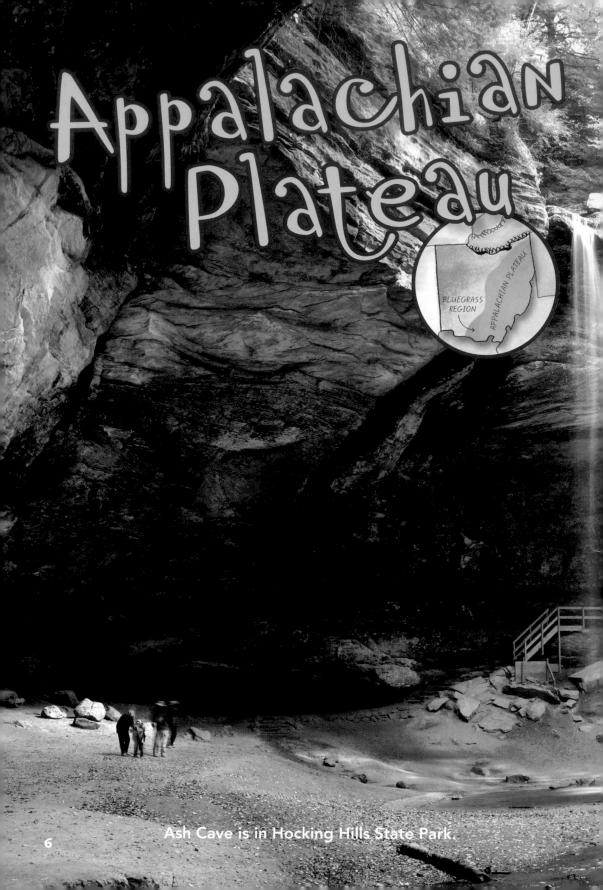

The Appalachian Plateau region that covers much of the eastern part of the state is part of the foothills of the Appalachian Mountains.

What's so special about the Appalachian Plateau region?

This region has Ohio's most abundant deposits of coal. But what's aboveground is far more beautiful! The northern part of the region consists of rolling hills and valleys. The southern part has steeper hills—waterfalls and valleys.

What can I see in the Appalachian Plateau region?

Lots of trees for sure! Some of the finest hardwood timber in the world is grown here mostly oak and hickory. There are also some pretty amazing natural land formations. Rock Bridge in Hocking Hills State Park is the longest natural bridge in the state. This natural arch formed after thousands of years of erosion wore away the softer rock underneath the harder rock on top.

Don't forget the Bluegrass region!

A small region shaped like a triangle is at the very southern part of Ohio. It extends into Kentucky and Indiana and gets its name from a type of grass bluegrass, of course—that is common in this area.

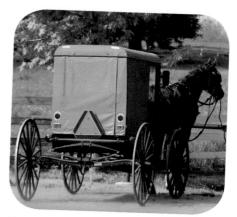

Horse and buggies are common in the Amish counties of the Appalachian Plateau region.

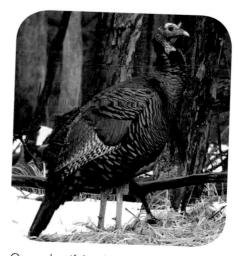

Once plentiful, wild turkeys disappeared from Ohio by 1904. However, natural populations gradually began moving back into southeastern Ohio. The bird is now slowly making a comeback throughout the state.

Lakes and Ravers

A sunset over Lake Erie in Cleveland, Ohio.

Natural and man-made lakes can be found throughout Ohio. The largest is the glacier-carved Lake Erie. There are also more than 3,300 named rivers and streams throughout the state.

Why are the lakes and rivers so special?

Lakes and rivers provide recreation, food, habitats, and water to drink! In Ohio, lakes and rivers have played an especially important role in transportation, too.

The Lake Erie shoreline makes Ohio part of the Great Lakes navigation system. This means ships from Ohio ports can connect with the Atlantic Ocean—and world markets—by way of the St. Lawrence Seaway.

At the southern end of the state, the Ohio River connects the state with a large inland river system. Huge barges move coal, petroleum products, and agricultural goods to and from over eighty five percent of the nation's major cities.

What can I see at lakes and rivers?

Punkys, goggle-eyes, and bullheads! A new rock group? Nope... these are the common names of some of the different kinds of fish swimming in Ohio's lakes and rivers.

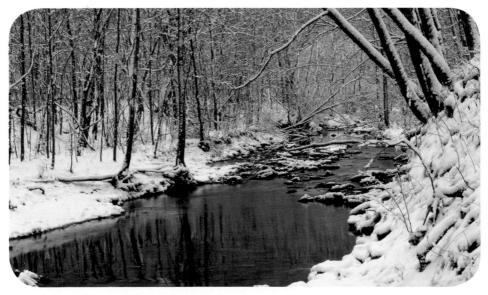

Although the water is still flowing in this creek in Keehner Park, cold Ohio winters can freeze the water in lakes, rivers, and creeks.

What's So Great About This State?

Well, how about...

Tell Me a Story!

What is now Ohio was first settled by ancestors of Native Americans called the Paleoindians. Later prehistoric cultures, such as the Adena, Hopewell, and Fort Ancient, built raised burial mounds that are still around Ohio today.

By the mid 1600s, the Iroquois were trading furs with Dutch, British, and French traders. To expand their hunting territory, the powerful Iroquois Confederacy drove out other Native American tribes in

the Ohio country. But during the 1700s, as the Iroquois tribes grew less powerful, other Native Americans including the Delaware, Miami, Ottawa, Mingo, and Wyandot moved back into the area.

> Tecumseh was a Shawnee leader who organized other tribes to resist white settlers. Tecumseh's Confederation eventually failed.

...The Story Continues

Eventually, Ohio became home to many other groups—including people of African, German, Irish, Scottish, English, Dutch, Swedish, and French ancestry. Many of the first settlers were farmers from the New England area. Later immigrants often came from Virginia, West Virginia, and Kentucky.

Although there were many French, Native American, and English battles over the years, the history of Ohio isn't all about war. Ohioans have always educated and invented. They have painted, written, sung, and built. Many footprints are stamped into the soul of Ohio's history. You can see evidence of this all over the state!

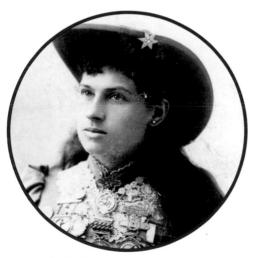

Annie Oakley (whose real name was Phoebe Ann Mozee) was born in Darke County, Ohio. She was an amazing sharpshooter who entertained people all over the world in Buffalo Bill's Wild West Show.

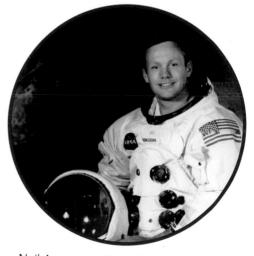

Neil Armstrong, from Wapakoneta, Ohio, was the first astronaut to walk on the moon. His historic message from the moon ("Tranquility Base here. The Eagle has landed.") was heard around the world on July 20, 1969.

The Hale Farm and Village is in Bath, Ohio.

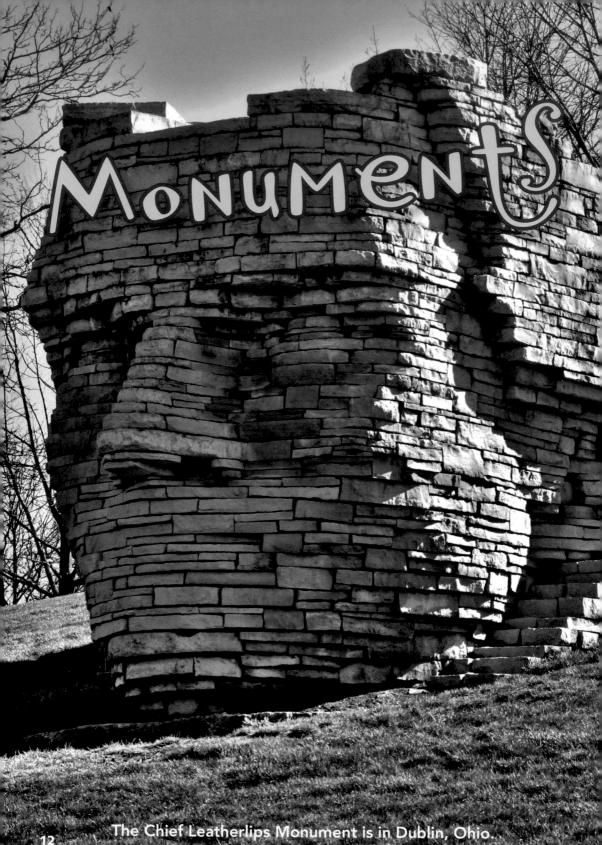

Monuments and memorials honor special people or events. The Leatherlips Monument remembers Wyandot Chief Shateyaronyah. He was called "Leatherlips" by settlers because he had a reputation for keeping his promises—his word was as strong as leather.

Why are the monuments in Ohio so special?

That's an easy one! There were many special people who helped build the state of Ohio. Some were famous soldiers and politicians. Others were just ordinary people who did "extraordinary" things to help shape both the state of Ohio and the nation.

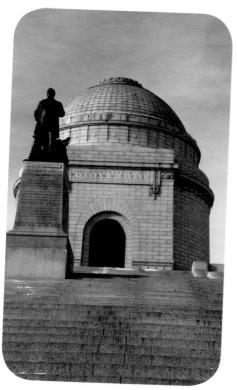

The McKinley National Memorial in Canton, Ohio honors William McKinley—the 25th president of the United States.

What kind of monuments can I see in Ohio?

There are many different kinds. There are statues, monuments, plaques—almost every town has found some way to honor a historic person or event.

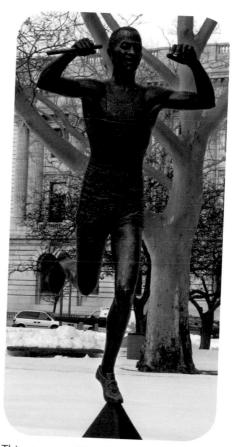

This statue in Cleveland honors athlete Jesse Owens, who won four gold medals in the 1936 Berlin Olympic Games.

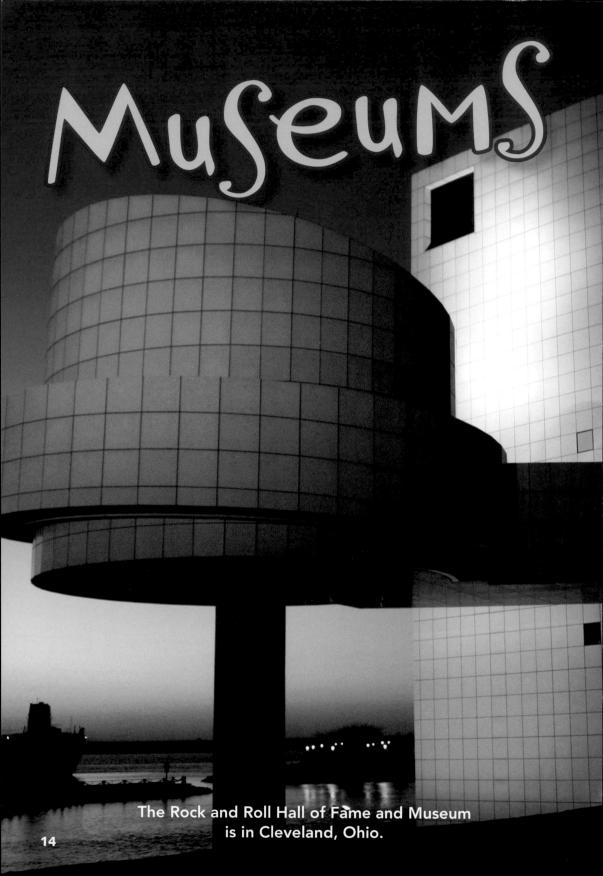

Museums don't just tell you about history—they actually show you artifacts from times past. Artifacts are things made by people, and they make history come alive!

Why are Ohio's museums so special?

Ohio's museums contain amazing exhibits with artifacts that tell the story of the state. For example, the National Underground Railroad Freedom Center Museum in Cincinnati tells the story of the Underground Railroad. During the 1800s, thousands of enslaved people sought freedom. The routes they traveled—and the people who helped them along the way—are considered part of the Underground Railroad.

What can I see in a museum?

An easier question to answer might be, "What can't I see in a museum?" There are thousands of items exhibited in all kinds of different museums across the state. Do you want to know about bicycles? The Pedaling History Bicycle Museum in New Bremen has the world's largest collection of antique and classic American bicycles. Are you interested in professional football? Then you might want to visit the Pro Football Hall of Fame in Canton, Ohio.

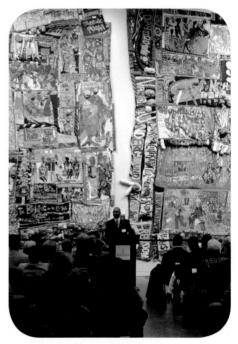

Aminah Robinson's RagGonNon art is at the National Underground Railroad Freedom Center. A RagGonNon is made of many things—including socks, beads, and music boxes—and it tells a rich story of African American life.

Imagine riding this high-wheel bike in 1885!

The Providence Metropark near Toledo shows what life was like on the Miami and Erie Canal in 1876.

OLUN

METROPARKS

exerc

\$+ ~

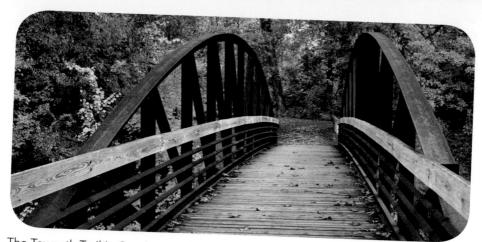

The Towpath Trail in Cuyahoga Valley National Park follows the historic route of the Ohio and Erie Canal.

More than 250 miles of waterway made up the Miami and Erie Canal that once connected the Ohio River in Cincinnati with Lake Erie in Toledo. At one time, more than 1,000 miles of canal waterways ran throughout the state.

Why were canals built in Ohio?

Canals were a clever solution to a transportation problem! By the early 1800s, Ohio's population had grown to over a half million people. Most were farmers who needed a way to move their products to bigger markets in different parts of the state and to the East Coast. (Remember, railroads didn't yet exist in the state.) So canals or man-made waterways were a good solution. Canals were Ohio's first state-wide transportation system.

EDO

What kind of horsepower did the boats use?

The thousand-pound, hayeating kind! Canal boats were pulled by horses, mules, or donkeys that walked on paths beside the canals. This means the boats could travel only as fast as the animals could walk which was about four to five miles per hour. But the animals could pull lots more weight on water than they could on land, so more goods could be shipped at one time.

> Mules were the animals of choice to pull canal boats. They could walk for hours and cover many miles!

What's So Great About This State?

Well, how about...

Enjoying the Outdoors

More than 11 million people live in the state of Ohio. Though they have different beliefs and traditions, Ohioans also have plenty in common.

Many share a love for the outdoors. Some of the best places for enjoying the great outdoors in Ohio are in the many state and national parks. And since Ohio has four seasons, choices for activities change all year long. Hiking in the fall, sledding in the winter, kayaking in the spring, swimming in the summer—the list of things that Ohioans enjoy goes on and on!

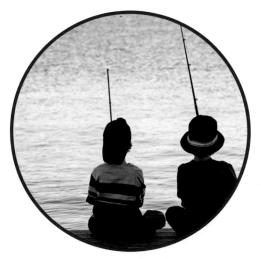

Fishing is popular in the summer.

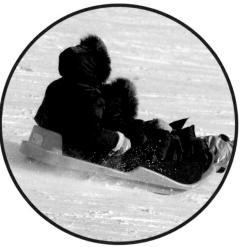

Sledding is great fun in the winter.

Sharing Traditions

In the towns and cities throughout the state, Ohioans share the freedom to celebrate different heritages. The great mix of cultures makes the state an interesting and exciting place to live.

For example, Central Ohio is home to the world's largest Amish community. The Amish trace their heritage back hundreds of years and still live and work much as their forefathers did.

Have you tried German sauerkraut or Italian sausage? How about buckeye candy? This popular Ohio treat looks like the nuts that fall from Ohio's state tree—the buckeye—but they're much tastier!

Making quilts is just one of the many crafts that are done by the Amish.

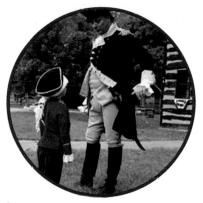

Ohio's history comes alive at Carillon Park in Dayton.

Protecting

A female Karner Blue Butterfly feeds on a lupine plant.

When wild lupine plants disappeared from Ohio, the Karner Blue butterfly lost its food source—so it disappeared, too! Luckily, both the plant and the butterfly are making a comeback in the Kitty Todd Preserve in Lucas County.

Why is it important to protect Ohio's natural resources?

The state of Ohio covers more than 44,000 square miles so it has lots of different environments within its borders. From rolling plains to rushing waterfalls, different environments mean that different kinds of plants and animals can live throughout the state. In technical terms, Ohio has great biodiversity! This biodiversity is important to protect because it keeps the environments balanced and healthy.

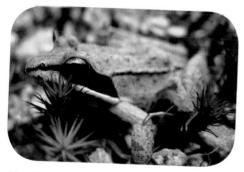

The Eastern Wood Frog becomes a "frogsicle" in the winter! Cold temperatures trigger a chemical reaction that allows the frog to produce special proteins and sugars to help it survive the winter. Although up to forty five percent of the frog's body can freeze, when warmer temperatures return in the spring, the frog thaws out just fine!

What kinds of organizations protect these resources?

It takes a lot of groups to cover it all. The U.S. Fish and Wildlife Service is a national organization. The Ohio Department of Natural Resources and the Ohio State Parks Service are state organizations. Of course, there are many other groups such as the Audubon Society and the Rachel Carson Council.

And don't forget...

You can make a difference, too! It's called "environmental stewardship," and it means you are willing to take personal responsibility to help protect Ohio's natural resources.

Inniswood Metro Gardens in Westerville is part of the central Ohio Metro Parks system that protects natural resources for people to enjoy.

Dairy farming is important in Ohio. The state is the number one producer of Swiss cheese in the nation.

Createng Tobs

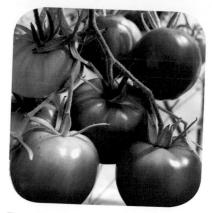

Tomatoes are an important crop. Tomato juice is even Ohio's state beverage.

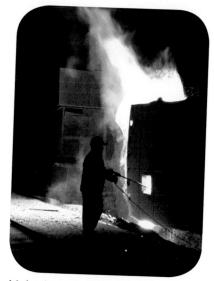

Melted steel is really hot! Ohio is one of the largest steel-producing states in the country.

Military training is hard work!

Some jobs have been done in Ohio for a long time. Farming is one of them. Other jobs are newer to the state. These involve research and renewable energy industries.

Why is Ohio a good place for business?

The land and the people make a good combination for a variety of businesses throughout the state.

What kinds of jobs are available throughout the state?

Agriculture is big. Corn, soybeans, apples, and pumpkins are just some of the crops grown in Ohio. Trees are even grown as a crop, to produce timber, in places called "tree farms." The land also supports a variety of livestock. From cattle and chickens to sheep and alpacas, Ohio farms are very busy places.

Another big industry is the service industry. Chefs, waiters, hotel clerks many jobs are needed to help tourists sightsee, eat, and relax!

Don't forget the military!

The Air Force, Army, Marines, Navy, and Coast Guard can all be found in the state. Ohioans have a great respect for all the brave men and women who train and work to serve our country.

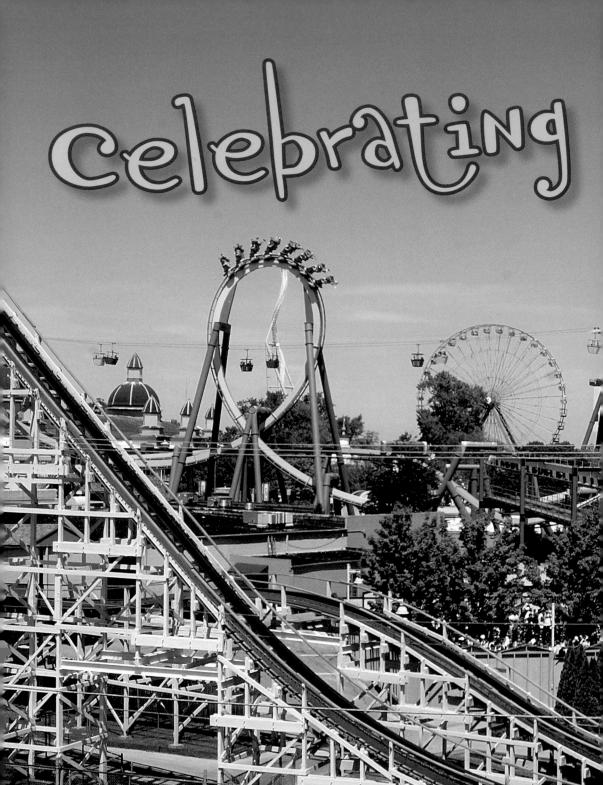

Cedar Point in Sandusky, Ohio, currently has more rides than any other amusement park. It's best known for its 17 roller coasters! The people of Ohio really know how to have fun! Cedar Point draws seven million visitors each year. It's one of the most popular places for people to visit in the whole state!

Why are Ohio festivals and celebrations special?

Celebrations and festivals bring people together. From cooking to frog-jumping contests, events in every corner of the state showcase all different kinds of people and talent.

What kind of celebrations and festivals are held in Ohio?

Too many to count! But one thing is for sure. You can find a celebration for just about anything you want to do. Do you like to eat corn on the cob? Ohio has seven different corn festivals every year. The Millersport Corn Festival at Buckeye Lake has been a celebration for over 60 years.

Do you like to watch car races? The Mid-Ohio Sports Car Course in Lexington races all kinds of cars, with some reaching 180 miles per hour. Want to see hot-air balloons? There are nine different hot-air balloon festivals each year throughout the state.

Don't forget the bathtub races!

Yes, it's true. Racing in bathtubs is all part of the Maple Festival in Chardon, Ohio. At this festival people celebrate the making (and eating!) of tasty maple syrup.

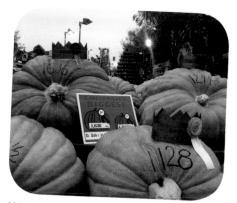

Winners of the 2009 Biggest Pumpkin contest at the Circleville Pumpkin Festival. The number on each pumpkin tells how many pounds it weighs!

You can get sauerkraut pizzas at the Waynesville Sauerkraut Festival. You can even get sauerkraut fudge!

What do all the people of Ohio have in common? These symbols represent the state's shared history and natural resources.

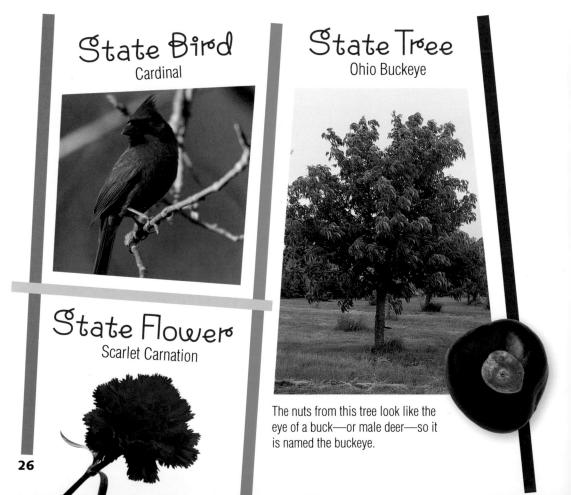

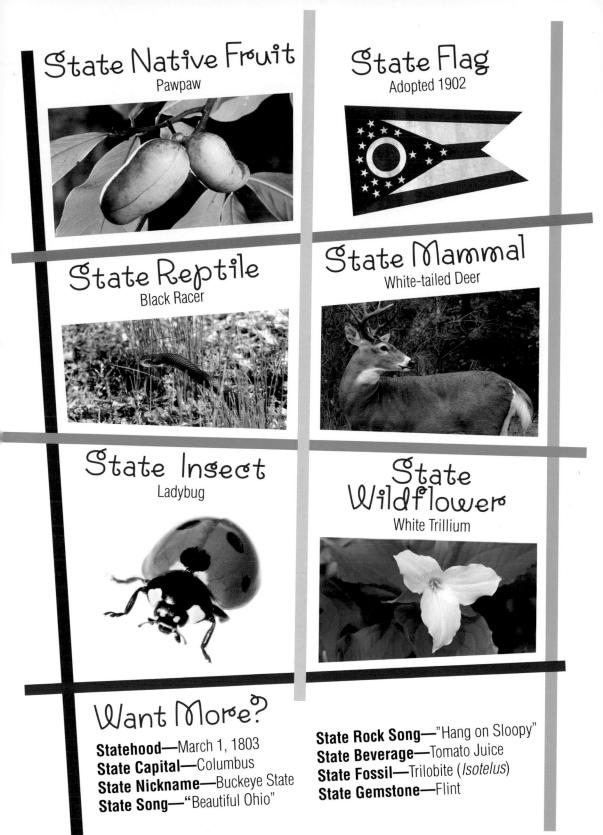

More

Here's some more interesting stuff about Ohio.

First City

Marietta (originally known as Adelphia) was the first settlement in the Northwest Territory in 1788.

President Patch

Seven U.S. presidents were born in Ohio: Ulysses S. Grant, Rutherford B. Hayes, James A. Garfield, Benjamin Harrison, William McKinley, William H. Taft, and Warren G. Harding.

Everyone Welcome

Oberlin College (founded in 1833) was the first interracial and coeducational college in the United States.

Toad Tuning

At the Cedar Bog in **Urbana**, people gather each spring to hear the toads sing! The bog's toads (and frogs!) are famous for their loud singing to attract a mate.

Weather Wonder

Buckeye Chuck is a groundhog from **Marion** known for predicting the arrival of spring.

Lights, Camera, Action

Some movies made in Ohio include The Shawshank Redemption, Air Force One, A Christmas Story, and Rain Man.

Big Business in Buttons

In the early 1900s the biggest employer in **Manchester** was the Manchester Button Factory. Mussel shells from the nearby Ohio River supplied the raw material.

Zip It!

The B.F. Goodrich company in **Akron** used inventor Gideon Sundback's fastener on a new type of rubber boot—and the name "zipper" was born.

Super Serpent

The prehistoric Fort Ancient culture built a 1,348-foot-long mound in the shape of a serpent that you can still see today in Adams County, Ohio.

Sewing Freedom

In the mid-1800s, women organized an Anti-Slavery Sewing Society in **Cincinnati** to make new clothing for people who were escaping slavery through the Underground Railroad.

An Apple a Day

Many of Ohio's first apple orchards began with saplings from John Chapman, better known as Johnny Appleseed.

Town Tribute

Mount Vernon, Ohio is named after the home of George Washington, which is Mount Vernon, Virginia.

Bienvenidos

Ohio's Hispanic community has grown by more than 22 percent since the year 2000.

Glass City Goes Solar

The first mass-produced glass bottles came from **Toledo**. Now the city is becoming known for producing glass solar panels.

Ohio River(s)

Major rivers in Ohio include the Ohio, Cuyahoga, Great Miami, Maumee, Muskingham, and Scioto rivers.

Pennant-Shaped Flag

The state flag of Ohio is the only state flag that is not shaped like a rectangle. The flag has a burgee design, which means it is cut in on one end—more like a pennant.

World's Largest Basket

The Longaberger Basket headquarters in **Newark** is a seven-story office building—shaped like a basket!

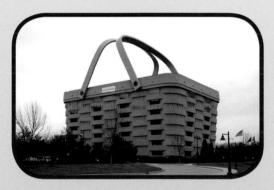

Wade In Lake Erie is the shallowest of the Great Lakes.

Find Out More

There are many great websites that can give you and your parents more information about all the great things that are going on in the state of Ohio!

State Websites

The Official Website of the State of Ohio www.ohio.gov

Ohio State Parks www.ohiodnr.com/parks

The Official Tourism Site of Ohio www.discoverohio.com

Museums

Columbus The Ohio Historical Society

www.ohiohistory.org

The Center of Science and Industry www.cosi.org

Cleveland

The Children's Museum of Cleveland www.clevelandchildrensmuseum.org

The Cleveland Museum of Natural History www.cmnh.org

The Rock and Roll Hall of Fame and Museum www.rockhall.com

Cincinnati

The National Underground Railroad Freedom Center www.freedomcenter.org

The Cincinnati Museum Center at Union Terminal www.cincymuseum.org

Toledo The Toledo Firefighters Museum

www.toledofiremuseum.com

Akron

The National Inventors Hall of Fame www.invent.org

Dayton

The National Museum of the US Air Force www.nationalmuseum.af.mil

Aquariums and Zoos The Cleveland Aquarium

www.clevelandaquarium.org

The Columbus Zoo and Aquarium www.columbuszoo.org

The Toledo Zoo www.toledozoo.org

The Cincinnati Zoo www.cincinnatizoo.org

Ohio: At A Glance

State Capital: Columbus

Ohio Borders: Pennsylvania, West Virginia, Kentucky, Indiana, Michigan, Lake Erie

Population: About 11 million

Highest Point: Campbell Hill is 1,549 feet (472 meters) above sea level

Lowest Point: Extreme southwestern Ohio at about 455 feet (139 meters) above sea level

Some Major Cities: Columbus, Cleveland, Cincinnati, Toledo, Akron, Dayton

Some Famous Ohioans

Dorothy Dandridge (1922–1965) from Cleveland, OH; was an actress and first African American to be nominated for an Academy Award.

Paul Laurence Dunbar (1872–1906) from Dayton, OH; was a nationally recognized American poet.

Thomas A. Edison (1847–1931) from Milan, OH; was an inventor who created such things as the lightbulb.

Benjamin F. Goodrich (1841–1888) lived in Akron, OH; was a surgeon and businessman who founded the B. F. Goodrich company. **Macy Gray** (born 1967) from Canton, OH; is a Grammy Award-winning singer, songwriter, and record producer.

Charles Kettering (1876–1958) from Loudonville, OH; was an inventor who created such things as the first electric ignition system for cars.

Judith Resnick (1949–1986) from Akron, OH; was an astronaut for NASA who received the Congressional Space Medal of Honor.

Harriett Beecher Stowe (1811–1896) lived in Cincinnati, OH; was a novelist who wrote the anti slavery story *Lincle Tom's Cabin*.

Orville Wright (1871–1948) from Dayton, OH; was an inventor who, with his brother Wilbur, built and successfully flew the first airplane.

Granville T. Woods (1856–1910) from Columbus, OH; was an inventor of such things as a telegraph that allowed messages to be sent from moving trains.

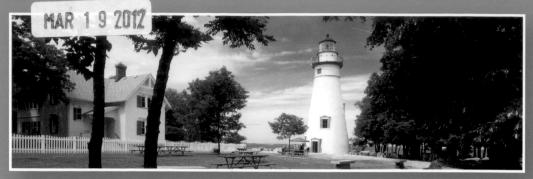

Marblehead lighthouse on Lake Erie

CREDITS

Series Concept and Development

Kate Boehm Jerome

Design

Steve Curtis Design, Inc. (www.SCDchicago.com); Roger Radke, Todd Nossek

Reviewers and Contributors

Dr. Connie Bodner, Director, Education and Interpretation Services, Ohio Historical Society; Terry B. Flohr, writer and editor; Mary L. Heaton, copy editor; Eric Nyquist and Todd Nossek, researchers

Photography

Back Cover(a) © photosbyjohn/Shutterstock; Back Cover(b), 7a © Rena Schild/Shutterstock; Back Cover(c), 24-25 Courtesy Cedar Point Amusement Park/Resort, Sandusky, OH; Back Cover(d), 8-9, 14-15 © Robert J. Daveant/Shutterstock; Back Cover(e), 6-7, 9, 17a © Doug Lemke/Shutterstock; Cover(a) © Bryan Busovicki/Shutterstock; Cover(b), 27d © Mike Rogal/Shutterstock; Cover(c), 26a © RLHambley/Shutterstock; 2a © Dave Kerr/Shutterstock; 3a © Jennifer Stone/Shutterstock; Cover(e) Courtesy of the Ohio Statehouse Photo Archive; Cover(f) © Phil Berry/Shutterstock; Cover(c), 26a © RLHambley/Shutterstock; 2a © Dave Kerr/Shutterstock; 3a © Jennifer Stone/Shutterstock; 3b © vadim kozlovsky/Shutterstock; 4-5 © Weldon Schloneger/Shutterstock; 5a © Cynthia Kidwell/Shutterstock; 2b © Tony Riv/Shutterstock; 7b © Bruce MacQueen/Shutterstock; 10-11 © Caitlin Mirra/Shutterstock; 10a © Indiana Historical Society; 11a © Billy Rose Theatre Collection/NYPL; 11b Courtesy NASA; 12-13 By Karl Hassel; 13a © Jesse Kunerth/Shutterstock; 13b By Donna Woods; 15a Courtesy National Underground Railroad Freedom Center, 15b © Ahmed Abusamra/Shutterstock; 16-17 By Dave Barber; 17b © electerra/Shutterstock; 18-19, 21b, 26d © aceshot1/Shutterstock; 18a © sonya etchison/Shutterstock; 18b aquatic creature/Shutterstock; 19a Christina Richards/Shutterstock; 20b © Studio 37/Shutterstock; 23c © John Wollwerth/Shutterstock; 23a © Jan WichaelZahniser/Wikimedia; 22-23 © Jean Frooms/Shutterstock; 23a © Olga Lipatova/Shutterstock; 23b © Studio 37/Shutterstock; 23c © John Wollwerth/Shutterstock; 27b © Hintau Aliaksei/Shutterstock; 27c © Daryl Vest/Shutterstock; 27e © Eric Isselée/Shutterstock; 27f © Olga Utyakova/Shutterstock; 28 © Terence Mendoza/Shutterstock; 29a © Olegro/ Shutterstock; 29b By Derek Jensen (Tysto)/Wikimedia; 31 © R. Gino Santa Maria/Shutterstock; 32t © Michael Shake/Shutterstock;

Illustration

Back Cover, 1, 4, 6 © Jennifer Thermes/Photodisc/Getty Images

Copyright © 2010 Kale Boehm Jerome. All rights reserved. No part of this book may be used or reproduced in any manner without written permission except in the case of brief quotations embodied in critical articles and reviews.

ISBN 978-1-58973-015-1 Library of Congress Catalog Card Number: 2009943371

1 2 3 4 5 6 WPC 15 14 13 12 11 10

Published by Arcadia Publishing Charleston SC, Chicago IL, Portsmouth NH, San Francisco CA

For all general information contact Arcadia Publishing at: Telephone 843-853-2070 Fax 843-853-0044 Email sales@arcadiapublishing.com For Customer Service and Orders: Toll Free 1-888-313-2665

Visit us on the Internet at www.arcadiapublishing.com